The

Autobiography of a Snake

EDITOR'S NOTE

Any resemblance of the snake,
a creative individual who loves celebrities,
to Andy Warhol,
a creative individual who loves celebrities,
is purely coincidental.

The Autobiography of a Snake

Drawings by

Andy Warhol

Thames & Hudson

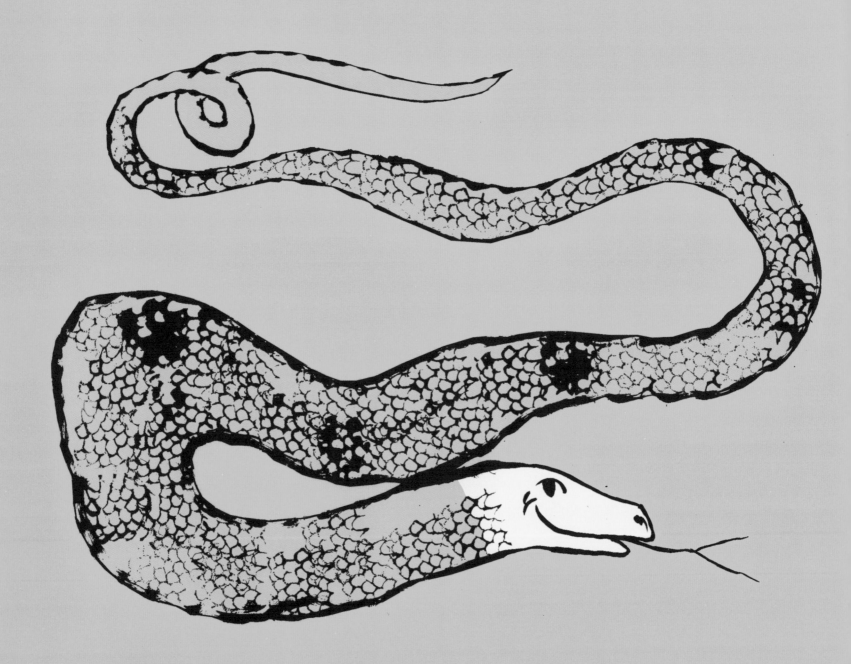

I am a snake.
I slither like a snake,
and I look like a snake,
but I have the
creative soul of
an artist and an actor.

I longed to be part
of high society,
so I reinvented myself.
I added color,
many colors!

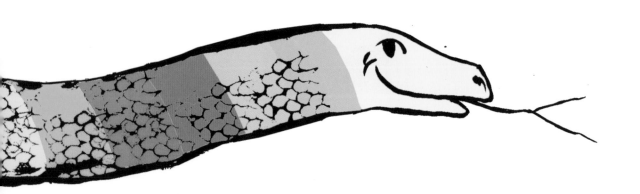

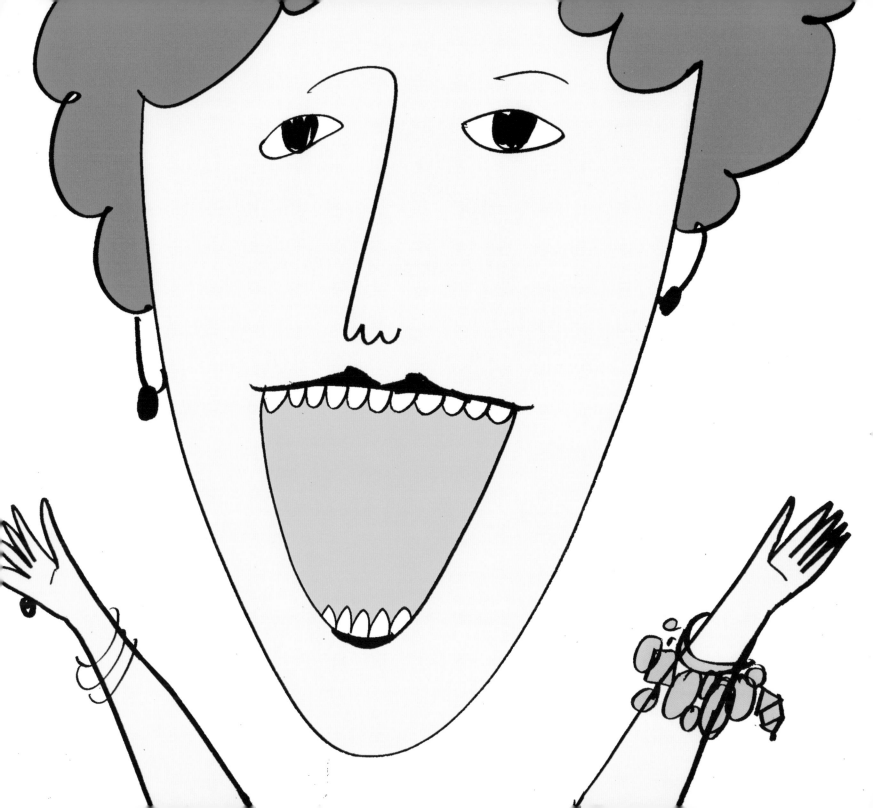

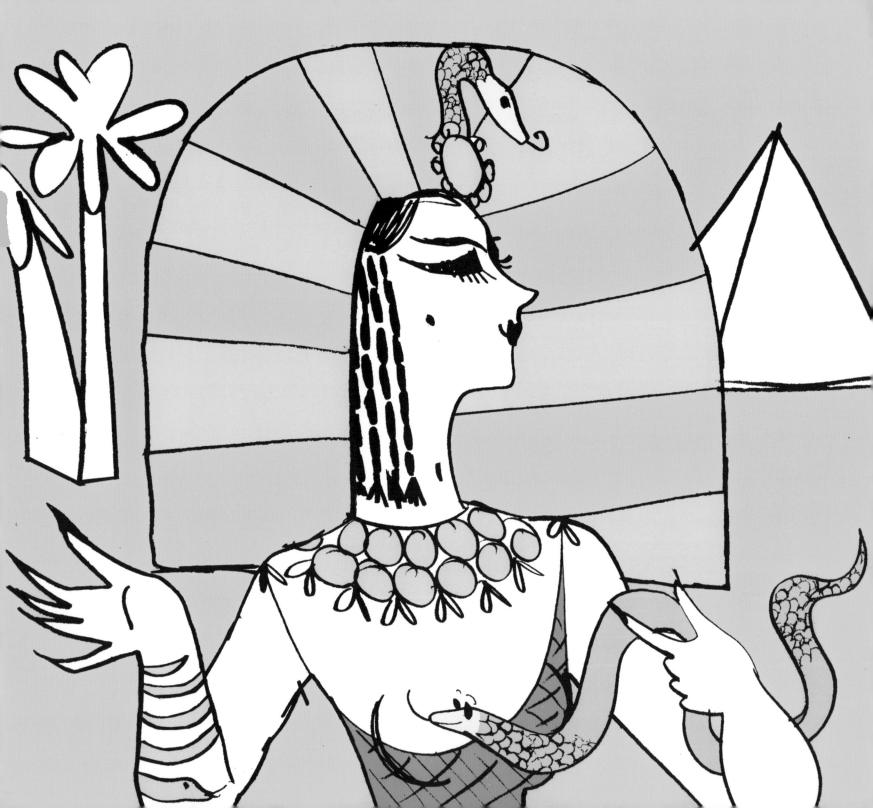

One of my

earliest starring roles was

as an asp for Cleopatra.

This was 34 B.C.

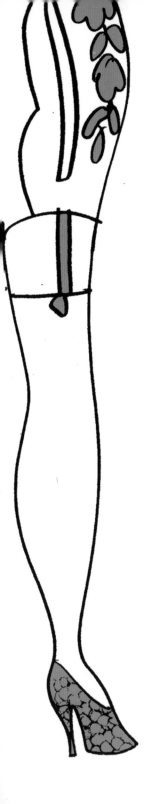

More recently
I became the darling
of women who needed me.
I gave them chic.

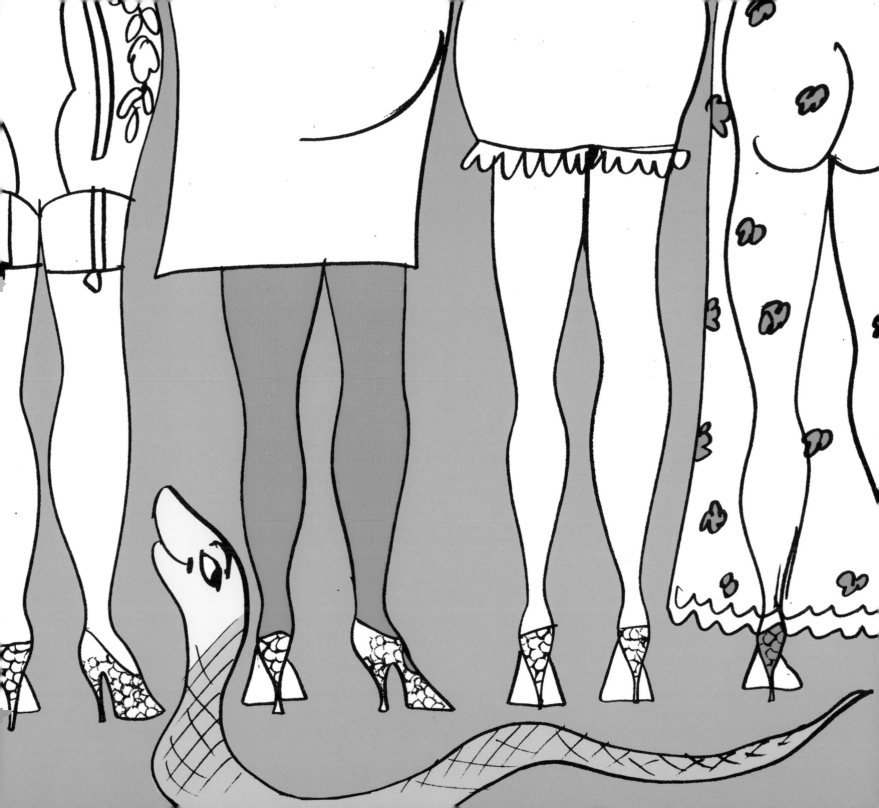

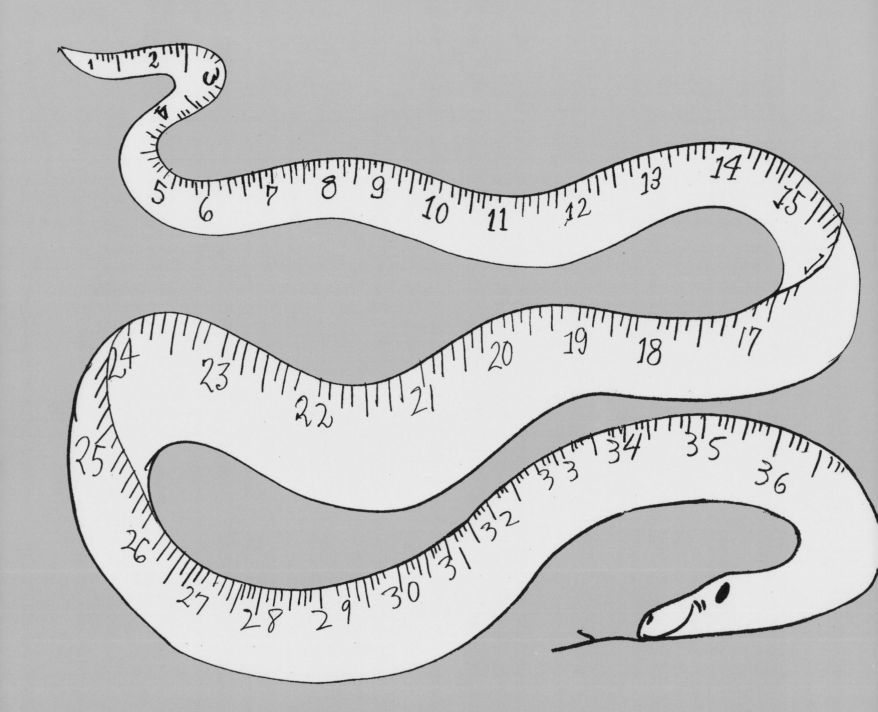

*A*s a belt
I could

squeeze an inch

off your waist.

This trick

made me

particularly popular.

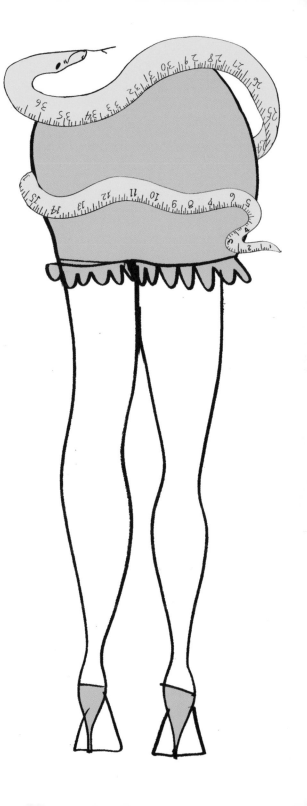

J became
Jacqueline Kennedy's boots.

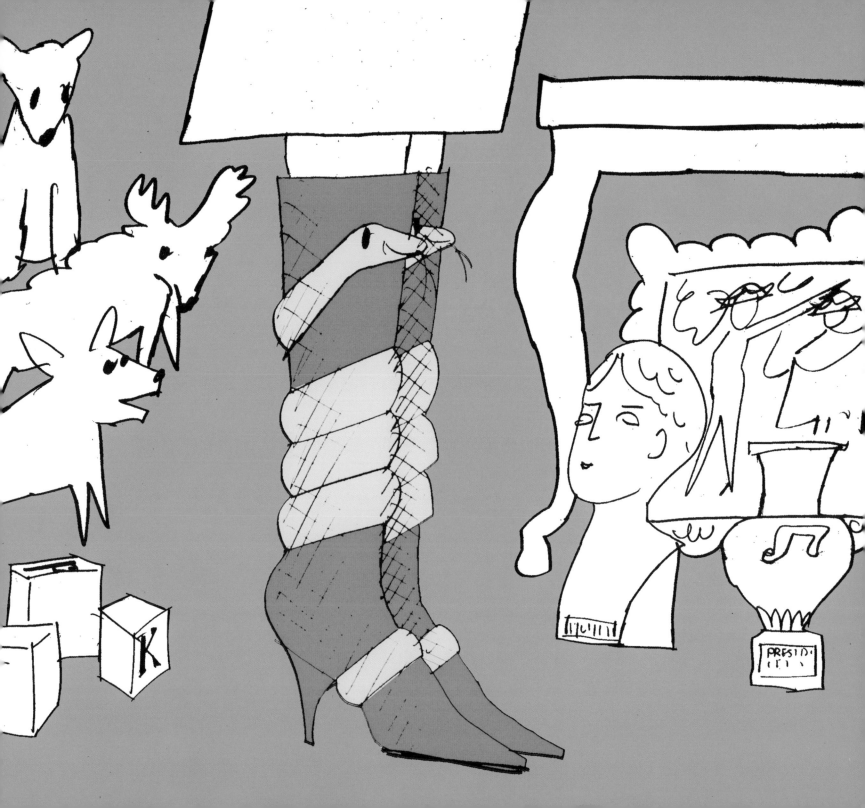

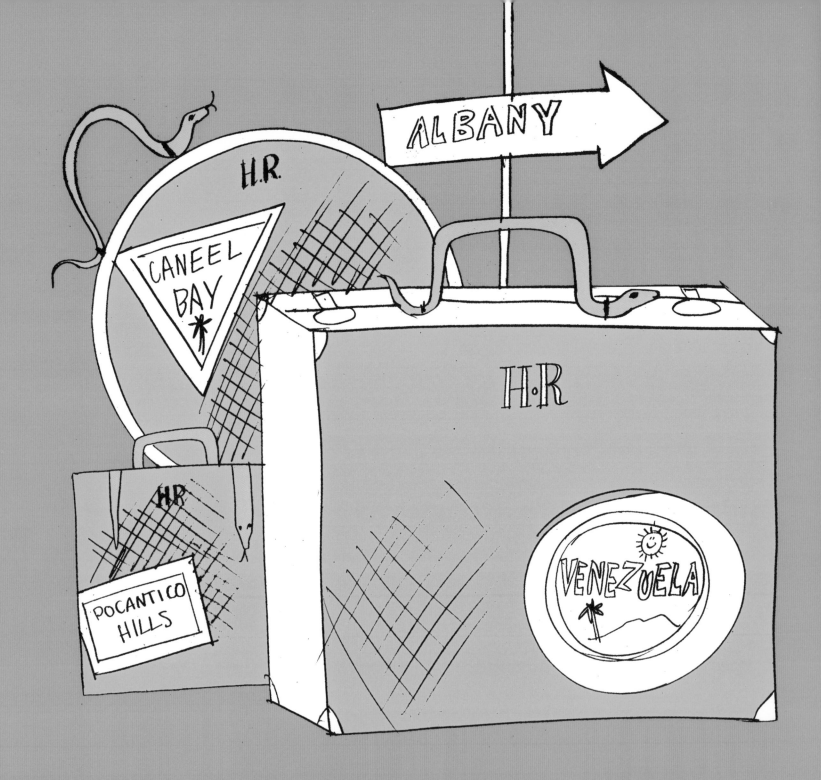

I was the luggage

for

Happy Rockefeller.

And

a hat for the other

Rockefeller, BoBo.

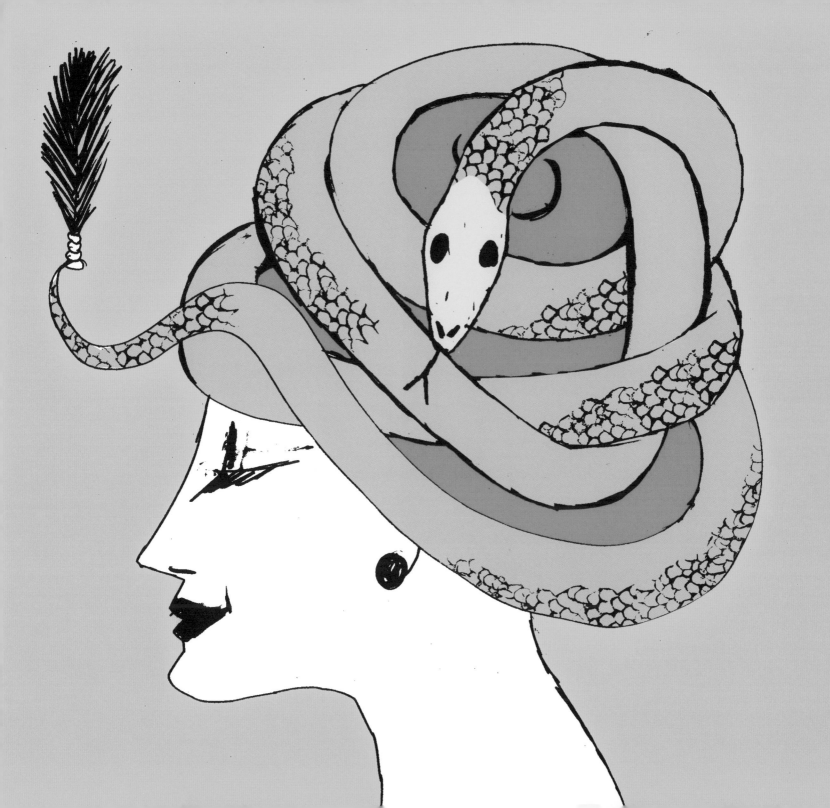

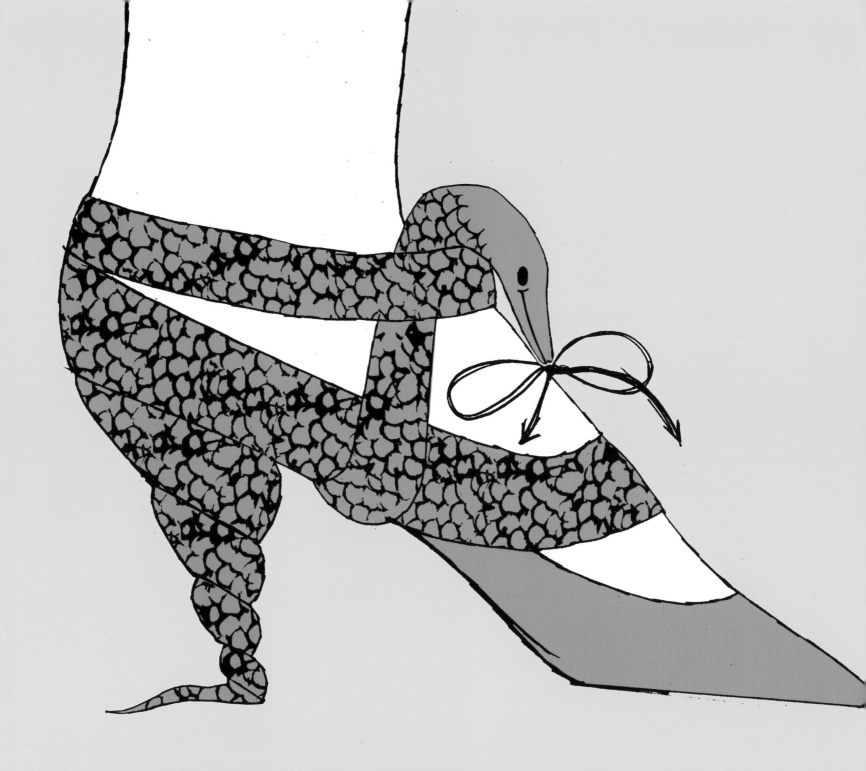

I became Diana Vreeland's chicest shoe. Even she loved me, eventually.

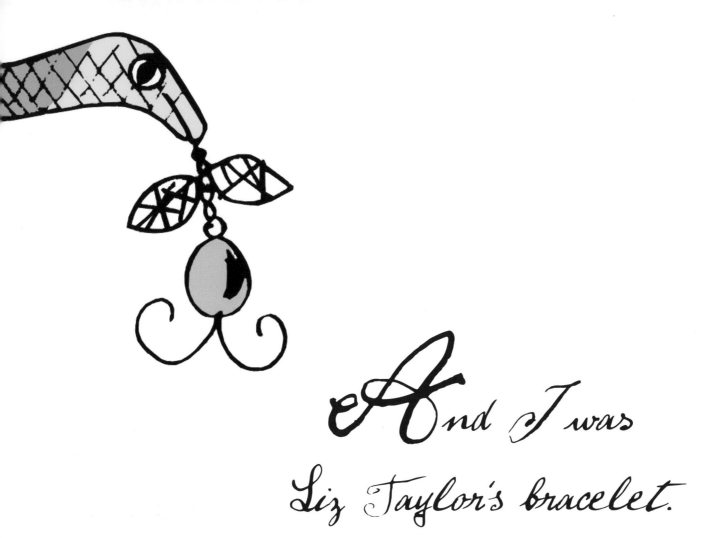

And I was
Liz Taylor's bracelet.

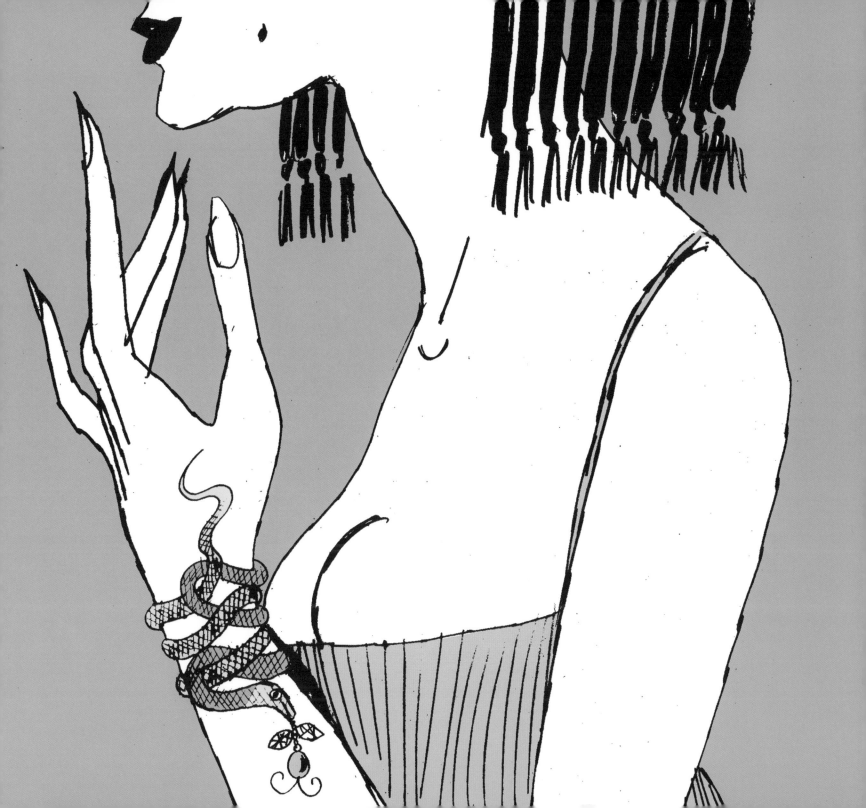

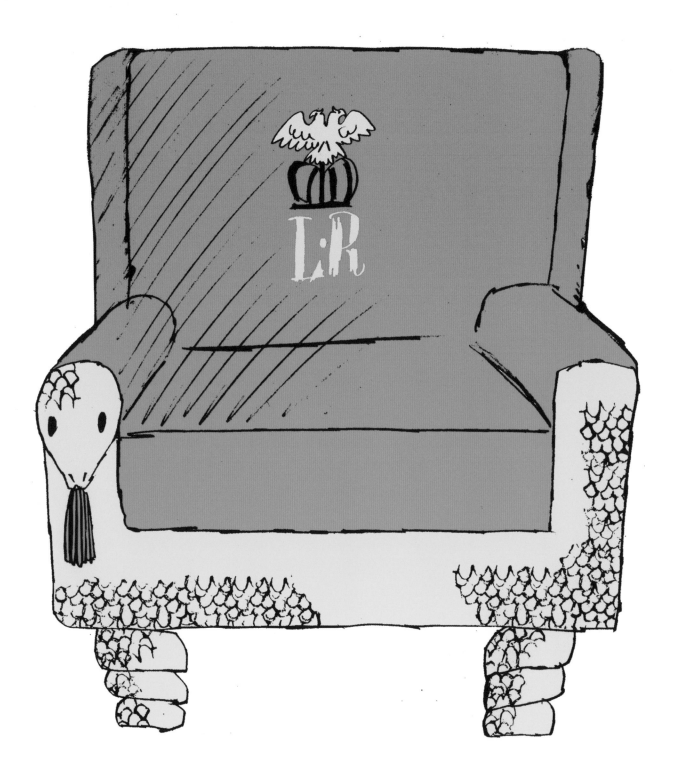

I decorated

a chair for

Princess Lee Radziwill.

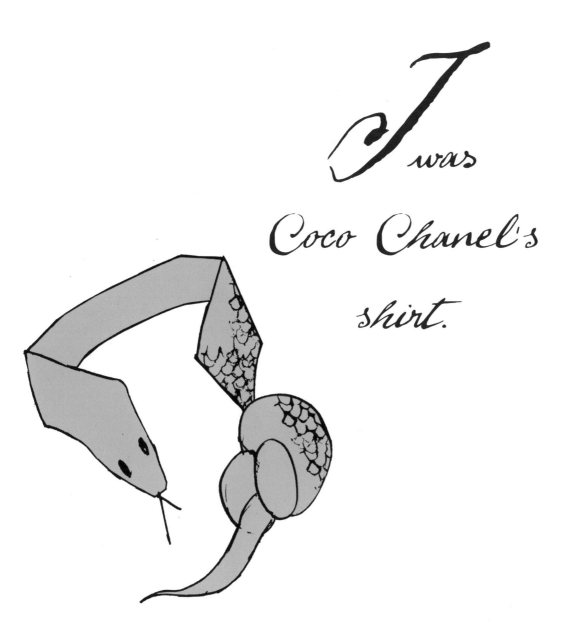

I was

Coco Chanel's

shirt.

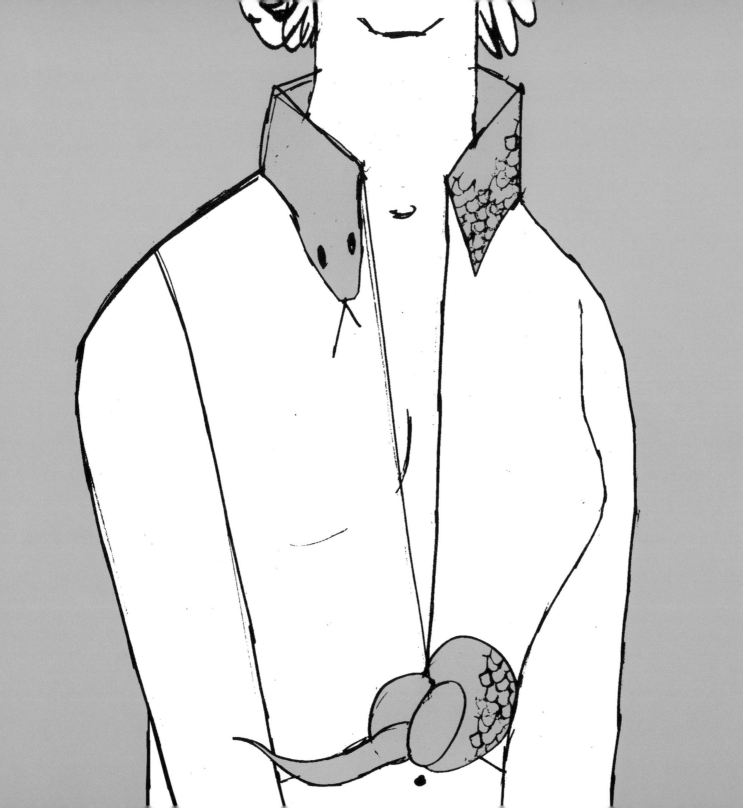

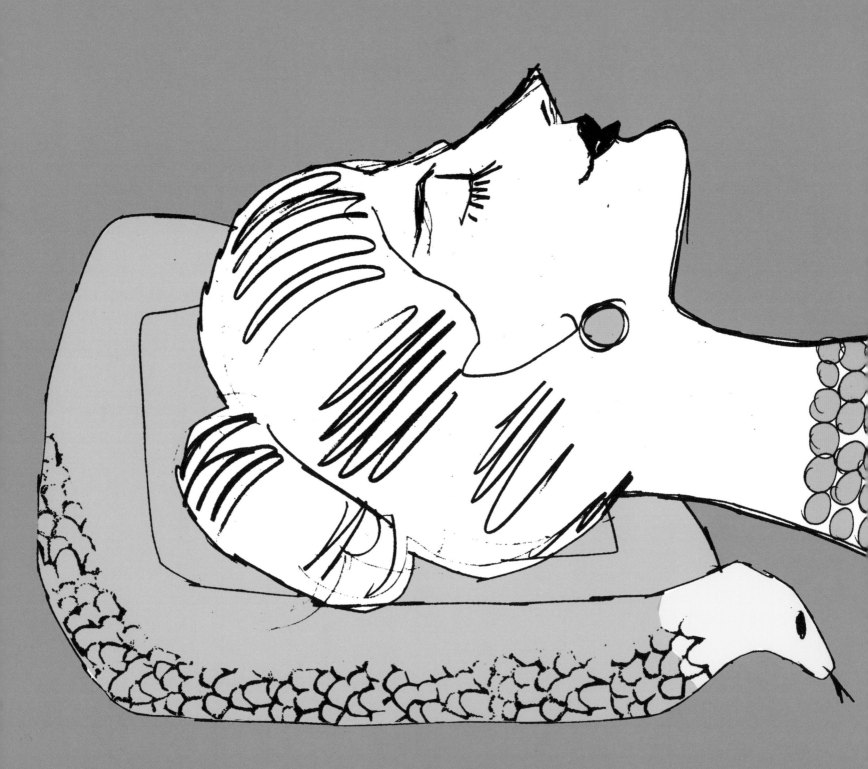

And Princess Grace's special pillow.

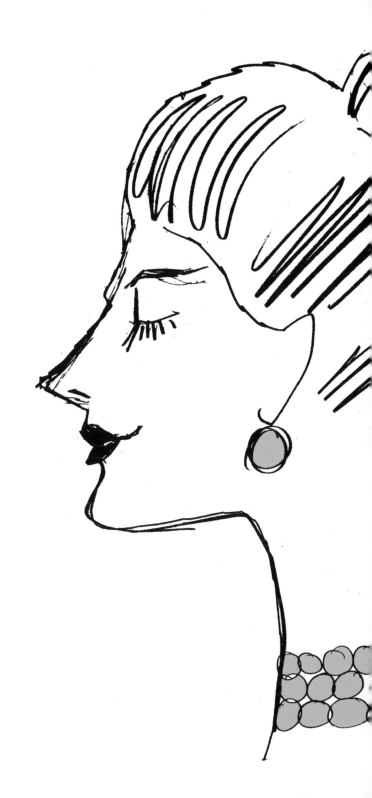

In London,
I hosted tea upon
a huge table
in the grand lobby
of Claridge's hotel.

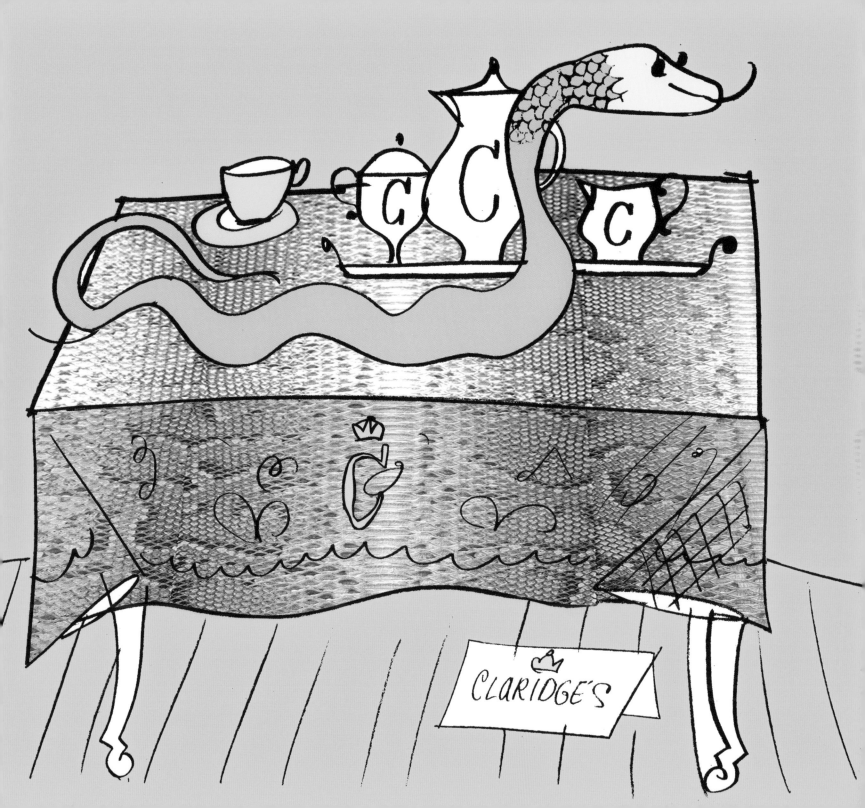

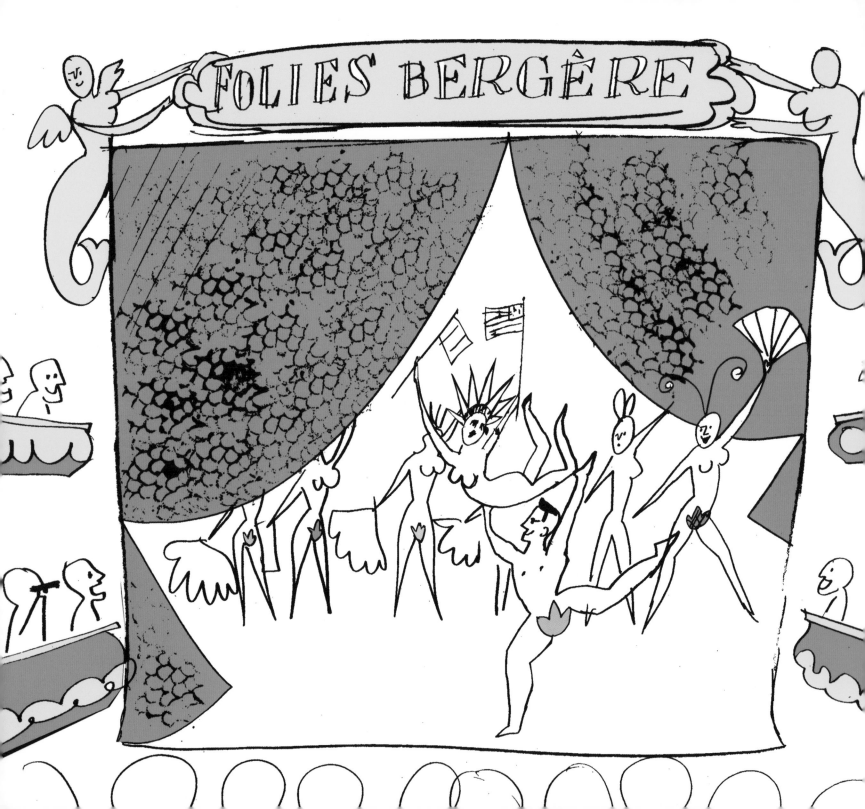

In Paris,
I was
the curtains for the
Folies Bergère.

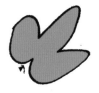

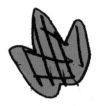

And
even the costumes for
the dancers.
(Oh, what a job!)

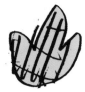

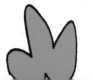

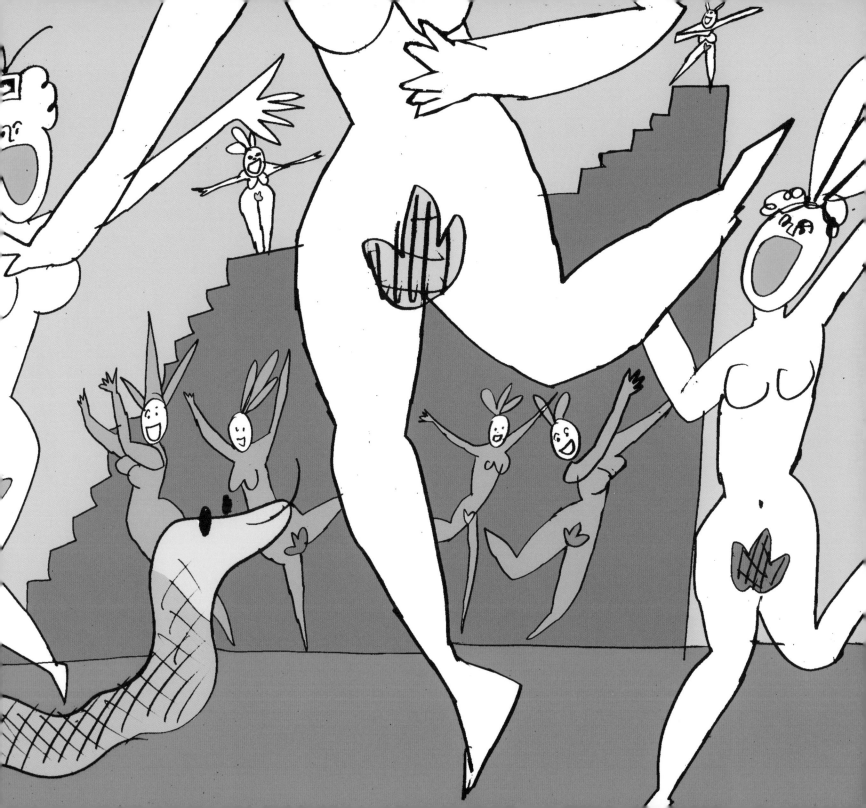

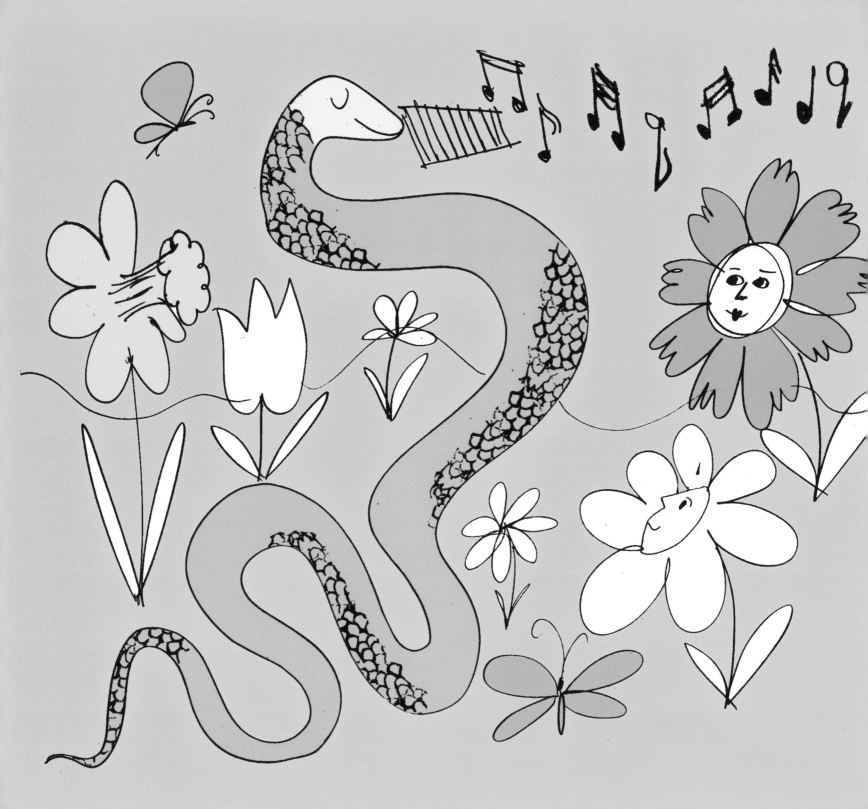

I could

be spring colors.

And fall colors,
like my pal Piaf.

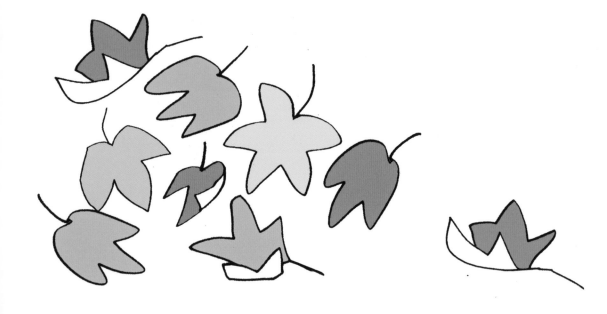

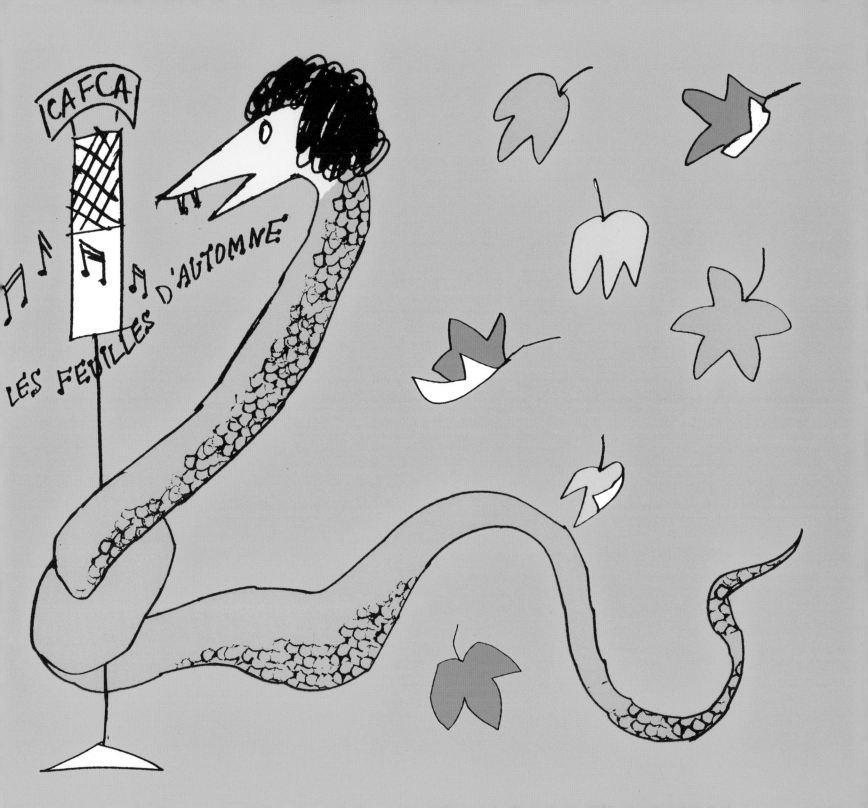

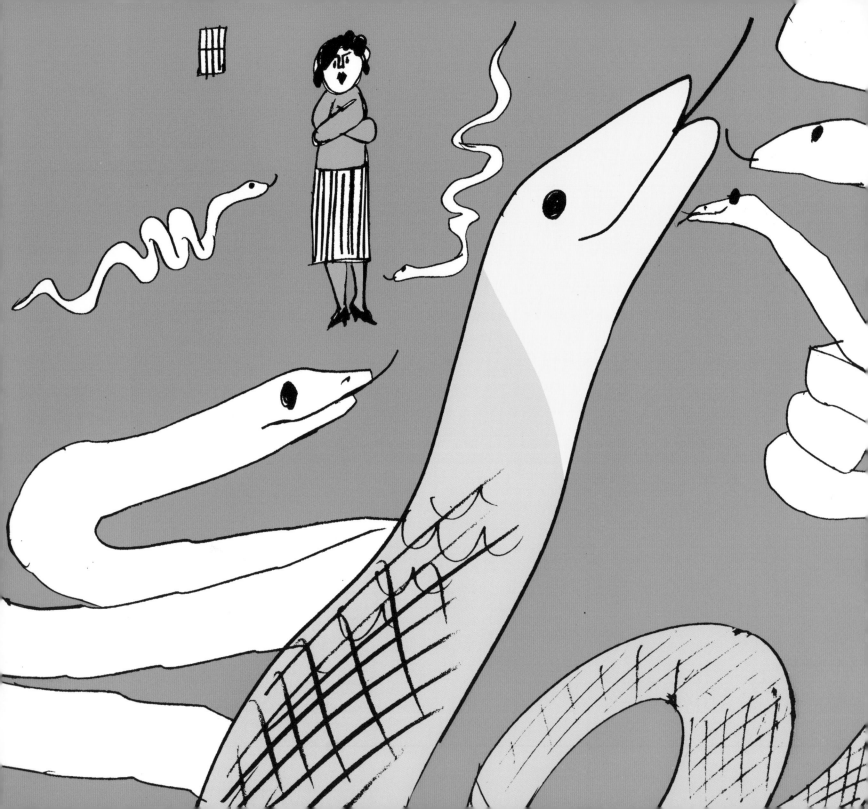

I've still got it:

rhythm, pattern,

and that runway slink.

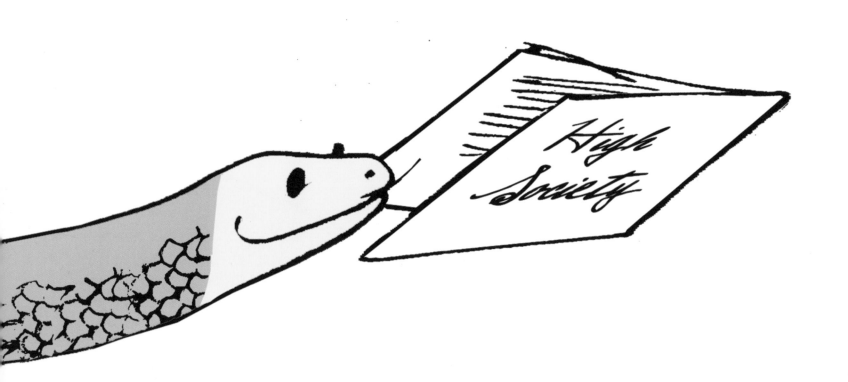

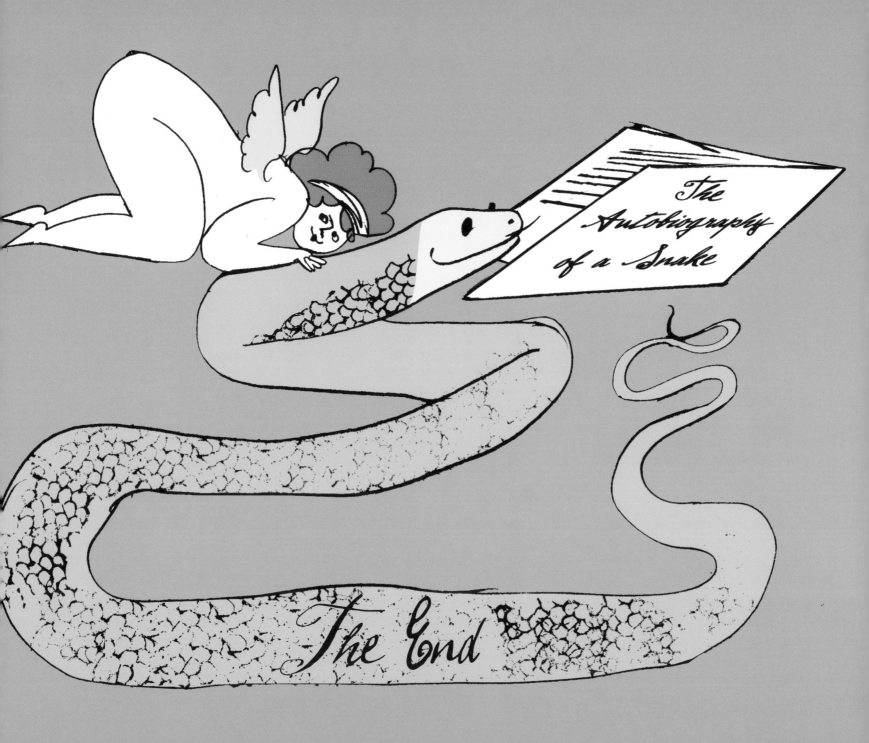

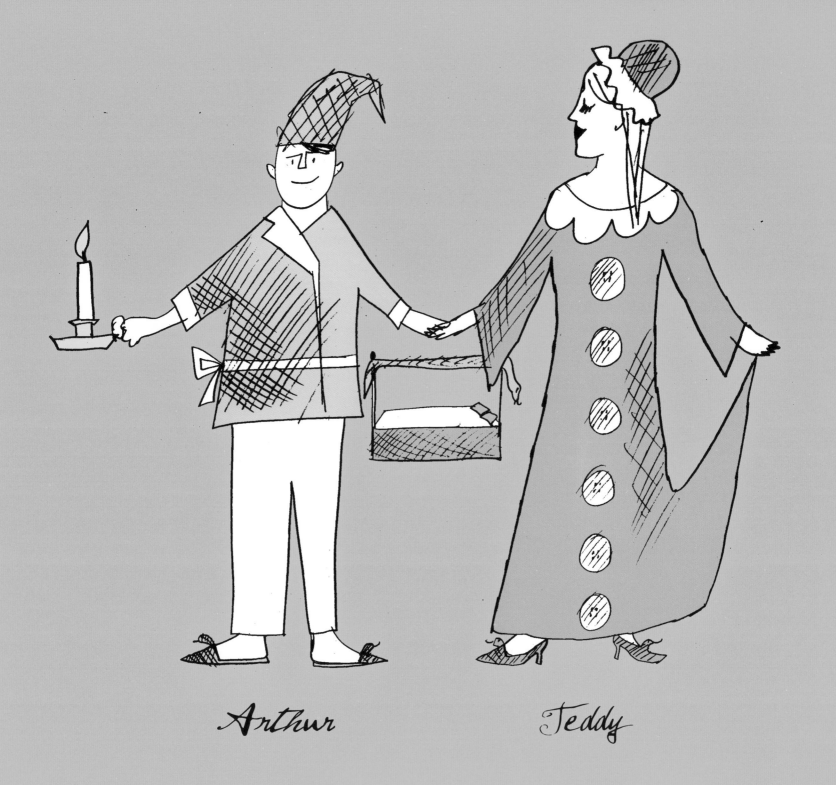

Arthur

Teddy

Afterword

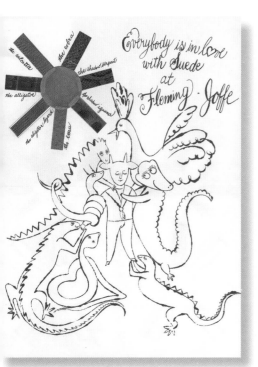

shoes, but also for jackets, handbags, upholstery, belts, wallets, and accessories, from the elegant to the fanciful. Andy created our swatch cards, our wrapping paper, shopping bags, magazine ads, and even a coloring book for our clients. He did the interiors for our trade shows. He painted an awning for our new showroom in St. Louis and the lamps for our company dining room. And he

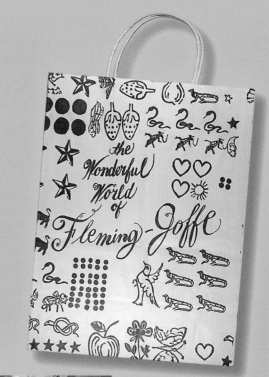

There was a time for Andy Warhol when success meant a job in New York, and we gave him a job. Our company was Fleming-Joffe, Ltd., our business was tanning reptile leathers—lizards, snakes, alligators—for use in the fashion industry. Much of our leather was for

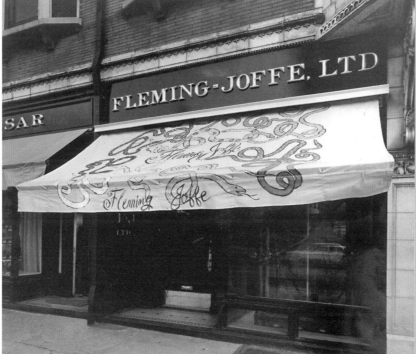

Opposite:
Andy's portrait of us in snakeskin pajamas.

Clockwise:
A shopping bag, decorated with the same pattern as our wrapping paper; our showroom in St. Louis with an unmistakable Warhol awning; a swatch card promoting our new line of snakeskin and suede in matching hues.

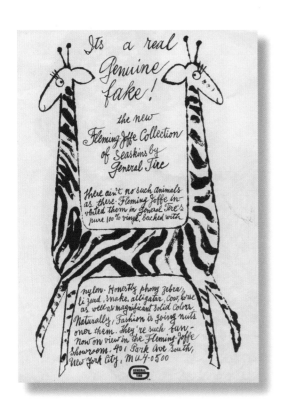

created "Genuine Fake" animals to promote our synthetic leather.

When our company won the prestigious Coty American Fashion Critics' Award in 1963 Andy created a series of slides to be run together as a film, with each slide representing a single frame, for the award ceremony at The Metropolitan Museum of Art.

This book is derived from Andy's first and only draft of the Coty

Award project. He chose a snake as our hero, "Noa the Boa." He made him a great actor playing many, many roles: a snake with a passion for fashion. Even when he was first starting out as an

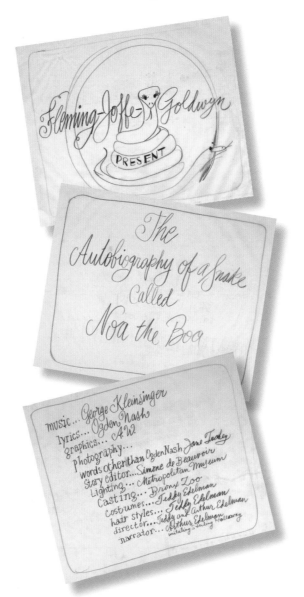

illustrator, Andy was a total celebrity junky. The women chosen for Noa's story were all fashion icons of the early '60s: First Lady Jacqueline Kennedy, Elizabeth Taylor, *Vogue* editor Diana Vreeland, Princess Grace, Lee Radziwill, Bobo Rockefeller, Happy Rockefeller, and more. And the institutions he refers to—the luxurious Claridge's hotel in London, the Folies Bergère—really were our customers.

As it turned out, Andy's film was never produced, and we later donated the drawings he created to the Warhol Museum in Pittsburgh.

Now, over fifty years later, we are publishing Noa's story for the first time, showcasing the talent that was evident in Andy's work from the beginning.

— Arthur and Teddy Edelman,
Ridgefield, Connecticut, 2016

this is a chair

this is a chair

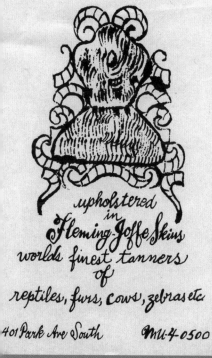

upholstered in Fleming-Joffe Skins
worlds finest tanners of
reptiles, furs, cows, zebras etc

401 Park Ave South MU-4-0500

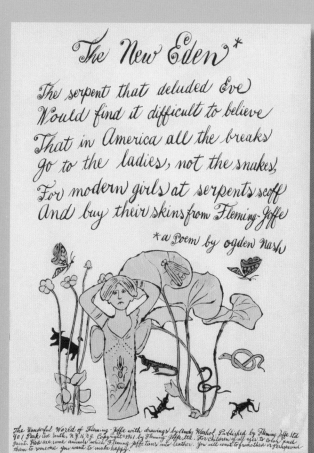

The New Eden*

The serpent that deluded Eve
Would find it difficult to believe
That in America all the breaks
Go to the ladies, not the snakes,
For modern girls at serpents scoff
And buy their skins from Fleming-Joffe

*a Poem by ogden nash

The Wonderful World of Fleming-Joffe with drawings by Andy Warhol. Published by Fleming Joffe Ltd 401 Park Ave South, N.Y 16 N.Y. Copyright 1961 by Fleming Joffe Ltd. For children of all ages to color and paint. Here are some animals which Fleming Joffe tans into leather. You will want to frame this or perhaps send them to someone you want to make happy.

Opposite:
Promotion for our synthetic leather and vinyl; the imaginary opening titles and credits for the Coty Award project.

Clockwise:
A page from a coloring book created for our clients; design for the "Jean Harlow," a heel with white crocodile and silver sequins; a promotion for a new color; a swatch card offering leathers and cloth in matching shades; an ad showing the transformative effect of our leathers.

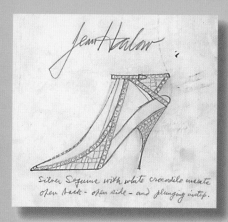

Jean Harlow

Silver Sequins with white crocodile inlate
open back - open side - and plunging instep.

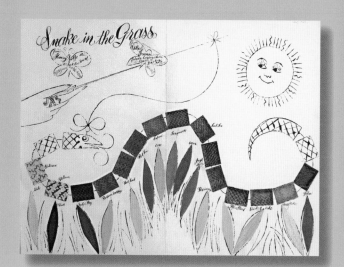

Snake in the Grass

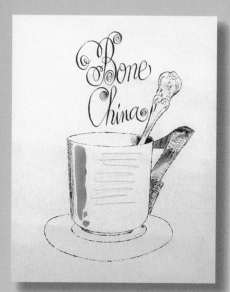

Bone China

The Autobiography of a Snake © 2016
The Andy Warhol Museum,
Pittsburgh, PA, a museum of
Carnegie Institute.
All rights reserved.

First published in the
United States of America in 2016
by Thames & Hudson Inc.,
500 Fifth Avenue,
New York, NY 10110

thamesandhudsonusa.com

Published in the United Kingdom
in 2016 by Thames & Hudson Ltd,
181A High Holborn,
London, WC1V 7QX

www.thamesandhudson.com

British Library Cataloguing-in-
Publication Data:
A catalogue record of this book is
available from the British Library.

ISBN: 978-0-500-51925-7

Designed by Miriam Berman,
Miriam Berman Graphic Design

a **ROBIE** book

Printed and bound in China.

Pages 4–47:
All works by Andy Warhol (American,
1928-1987) © The Andy Warhol Museum,
Pittsburgh, PA, a museum of Carnegie
Institute. Works included in this volume were
created for Fleming-Joffe, Ltd., New York, NY
and are gifts of Teddy and Arthur Edelman.

p.4
Noa the Boa, 1963
Graphite and ink on tracing paper
18¾ x 23⅞ in. (47.6 x 60.6 cm.)

p.7
Female (Close-Up), 1963
Graphite on tracing paper
18¾ x 24 in. (47.6 x 61 cm.)

p.8
Cleopatra, 1963
Graphite on tracing paper
18¾ x 23⅞ in. (47.6 x 60.6 cm.)

p.11
Snake and Four Pairs of Female Legs, 1963
Graphite on tracing paper
18¾ x 24 in. (47.6 x 61 cm.)

p.12
Snake (Tape Measure), 1963
Graphite on tracing paper
18¾ x 24 in. (47.6 x 61 cm.)

p.15
Jackie's Boots..., 1963
Graphite on tracing paper
18¾ x 23⅞ in. (47.6 x 60.6 cm.)

p.16
Happy's Luggage, 1963
Graphite on tracing paper
18¾ x 23⅞ in. (47.6 x 60.6 cm.)

p.19
BoBo's Hat, 1963
Graphite on tracing paper
18¾ x 23⅞ in. (47.6 x 60.6 cm.)

p.20
Diana's Shoe, 1963
Graphite on tracing paper
18¾ x 24 in. (47.6 x 61 cm.)

p.23
Liz's Bracelet, 1963
Graphite on tracing paper
18¾ x 23⅞ in. (47.6 x 60.6 cm.)

p.24
Princess Lee's Chair, 1963
Graphite on tracing paper
18¾ x 24 in. (47.6 x 61 cm.)

p.27
CeCe's Shirt, 1963
Graphite on tracing paper
18¾ x 24 in. (47.6 x 61 cm.)

p.28
Princess Grace's Pillow, 1963
Graphite on tracing paper
18¾ x 24 in. (47.6 x 61 cm.)

p.31
Claridges, 1963
Graphite and ink on tracing paper
18¾ x 24 in. (47.6 x 61 cm.)

p.32
Folies Begere, 1963
Graphite and ink on tracing paper
18¾ x 24 in. (47.6 x 61 cm.)

p.35
Dancing Females with Snake, 1963
Graphite on tracing paper
18¾ x 24 in. (47.6 x 61 cm.)

p.36
I Was Spring, 1963
Graphite on tracing paper
18¾ x 24 in. (47.6 x 61 cm.)

p.39
**Les Feuilles D'Autumne
(I Was Fall / Edith Piaf Wig),** 1963
Graphite on tracing paper
18¾ x 24 in. (47.6 x 61 cm.)

p.40
Female with Snakes, 1963
Graphite and ink on tracing paper
18¾ x 24 in. (47.6 x 61 cm.)

p.43
The End, 1963
Graphite and ink on tracing paper
18¾ x 24 in. (47.6 x 61 cm.)

Afterword:
p.44:
**Teddy & Arthur in Pajamas
of Snakeskin...,** 1963
Graphite and ink on tracing paper
18¾ x 24 in. (47.6 x 61 cm.)

p.45 (clockwise):
The Wonderful World of Fleming-Joffe,
ca.1958–1964
Shopping Bag
Printed ink on paper
16¾ x 13 inches, (42.5 x 33 cm.)

Storefront (Fleming-Joffe, Ltd.), 1960
Reprint 1994, Photographed by W.C. Ru
Photo Co. Inc, St. Louis, MO
Gelatin silver print
8 x 10 in. (20.3 x 25.4 cm.)

**Everybody is in Love with Suede at Flem
Joffe,** ca.1958-1965
Offset lithograph, dyed reptile skin, and
collage on Strathmore paper
24 x 18 in. (61 x 45.7 cm.)

p.46 (clockwise):
Tear Sheet, *Glamour,* **July, no year**
Advertisement, 1963
Printed ink on coated paper
11⅜ x 9½ in. (28.9 x 21.6 cm.)

**Three works: Introduction, Production 1
Credits,** 1963
George Kleinsinger, American, 1914–19
(listed)
Ogden Nash, American, 1902–1971 (lis
Simone de Beauvoir, French, 1908–198
(listed)
Sterling Holloway, American, 1905–199
(listed)
All graphite on tracing paper
18¾ x 24 in. (47.6 x 61 cm.)

p.47 (clockwise):
The New Eden (detail), 1961
"The Wonderful World of Fleming-Joffe,
Ogden Nash, American, 1902–1971 (au
Coloring book: cardboard covers with b
fabric tape binding, printed ink on paper
leather collage elements, and crayon
Overall:19¾ x 14¼ in. (50.2 x 36.2 cm.)

Jean Harlow (detail), ca.1958–1965
Graphite and tracing paper mounted
to mat board
8¾ x 8⅝ in. (22.2 x 21.9 cm.)

Bone China, 1964
Ink, graphite, and wash on
Strathmore paper
23 x 14⅝ in. (58.4 x 37.1 cm.)

Snake in the Grass, 1964
Offset lithograph, dyed reptile skin, and
fabric collage on paper
18 x 23¾ in. (45.7 x 60.3 cm.)

**This is a chair, this is a chair upholstere
Fleming-Joffe skins,** *Interiors,* 1963
Advertisement
Printed ink on coated paper
10⅝ x 3¾ inches (27 x 9.5 cm.)